A GENERAL INTRODUCTION TO THE
CORPUS OF ANGLO-SAXON STONE SCULPTURE

Grammar of Anglo-Saxon Ornament

A GENERAL INTRODUCTION TO THE
CORPUS OF ANGLO-SAXON
STONE SCULPTURE

BY

ROSEMARY CRAMP

Published for THE BRITISH ACADEMY
by OXFORD UNIVERSITY PRESS

Oxford University Press, Walton Street, Oxford OX2 6DP

Oxford New York
Athens Auckland Bangkok Bombay
Calcutta Cape Town Dar es Salaam Delhi
Florence Hong Kong Istanbul Karachi
Kuala Lumpur Madras Madrid Melbourne
Mexico City Nairobi Paris Singapore
Taipei Tokyo Toronto

and associated companies in
Berlin Ibadan

First published by the British Academy, as Corpus of Anglo-Saxon
Stone Sculpture: General Introduction, 1984
First published by Oxford University Press, as Grammar of
Anglo-Saxon Ornament, 1991
Reprinted, 1995

ISBN 0–19–726098–5

Printed in Great Britain by
WBC Limited, Bridgend

FOREWORD

The University of Durham has felt privileged to have housed this important project, not only for its significant contribution to scholarship, but because the work has captured interests and imaginations far beyond academic walls.

Professor F. G. T. HOLLIDAY, C.B.E., F.R.S.E.
Vice-Chancellor and Warden

PREFACE

THE pre-Romanesque stone sculpture of all parts of the British Isles, other than England, has been listed and described already (Scotland: Stuart 1856 and 1867, Allen 1903; Wales: Nash-Williams 1950; Ireland: Henry 1933; Isle of Man: Kermode 1907).[1] In the past, several scholars began the much more extensive task of producing a corpus of English stone sculpture from this period, but no corpus was completed.

As early as 1885 J. Romilly Allen assisted by G. F. Browne listed what was then known of Anglo-Saxon sculpture (Allen and Browne 1885, 333–58). G. Baldwin Brown's work on sculpture was unfinished at his death and published posthumously (Brown 1937). T. D. Kendrick established in the British Museum a collection of photographs and a card index of English sculpture material, and in so doing laid a firm basis for a national study. Kendrick did not publish a corpus, but many of his conclusions about chronology and schools of carving are to be found in his two major works on pre-Conquest art in England (Kendrick 1938; ibid. 1949).

In addition, there exist many regional studies. The most noteworthy of these are the catalogues and surveys of W. G. Collingwood (Collingwood 1907; ibid. 1909; ibid. 1911; ibid. 1915). Unfortunately he did not complete the work for the whole of England, although his notebooks in the Ashmolean Museum, Oxford, indicate that he intended to extend his range. There are also hand-lists for many other counties, some scattered in local archaeological journals and small handbooks, others produced as part of larger regional surveys, such as the Victoria Histories of the Counties of England and the Royal Commission Inventories of Ancient and Historical Monuments.[2] These works are of different dates and do not use the same terminology or system of classification.

Notable, and more recent, contributions have been made, however, by scholars interested in one particular type or aspect of sculpture. The work of H. M. and J. Taylor, in their three volumes on Anglo-Saxon architecture and in an article, provides a modern check-list of architectural sculpture (Taylor and Taylor 1965; Taylor and Taylor 1966; Taylor 1978). Inscriptions on sculpture have always produced much scholarly comment, and these have been recently considered: non-runic inscriptions by E. Okasha (1971) and runic inscriptions by H. Marquardt (1961) and R. I. Page (1973).

The small number of pieces of Anglo-Saxon sculpture listed in Allen and Browne in 1885 – 164 localities and 197 pieces in all – contrasts very markedly with the tally less than one hundred years later, when Durham and Northumberland alone have produced 579 pieces from sixty-five sites, instead of twenty-eight pieces in all. New examples are being brought to light by controlled excavations, chance discoveries or simply more precise recognition. It is therefore clear that any catalogue will have to be kept up to date, and many deductions will have to be revised in the light of further discoveries.

1. Other European nations, such as Italy and France, are in the process of publishing their corpora. In Italy the material is published by diocese (e.g. Belli 1959). In France the division is by area, including the museum collections whose material is gathered from different regions; the first volume – Paris – has recently been published (Fossard, Vieillard-Troiekouroff and Chatel 1978).
2. The following are intended to be only a representative selection; a full bibliography will accompany each volume. Cheshire and Lancashire: Allen 1895; East Anglia: Fox 1922; Derbyshire: Routh 1937; Lincolnshire: Davies 1926; Wiltshire/Somerset: Cottrill 1935, Allen 1894; Hampshire: Green and Green 1951; Yorkshire: Collingwood 1907, 1909, 1911, 1915.

However, since this series will not be the work of a single author and since re-evaluation of the material will be simplified if a common vocabulary and system of description is used, it has been considered useful to provide a handbook of descriptive reference for the whole series.[3]

Durham ROSEMARY CRAMP

3. Other scholars are actively engaged in preparing material for this series and have taken part in decisions about the terminology and classification (their special interests are given in brackets): R. N. Bailey (Cumbria); J. T. Lang (Yorkshire); C. D. Morris (Yorkshire). I should like to record here my gratitude for their help and encouragement.

GENERAL INTRODUCTION TO THE SERIES

CONTENTS

FOREWORD v

PREFACE vii

LIST OF FIGURES xi

CHAPTER I. FORM OF CATALOGUE ENTRIES xiii

CHAPTER II. CLASSIFICATION OF FORMS AND SHAPES OF MONUMENTS xiv
 Free-standing crosses xiv
 Cross-shafts xiv
 Cross-heads xiv
 Tombs and grave-markers xiv
 Architectural sculpture and church furnishings xxi

CHAPTER III. TECHNIQUES OF CARVING xxii

CHAPTER IV. CLASSIFICATION OF ORNAMENT xxiv
 Mouldings xxiv
 Plant-scrolls xxiv
 Leaves xxiv
 Leaf compositions xxviii
 Fruit xxviii
 Interlace xxviii
 Constructional aids xxix
 The pattern lists xxix
 Interlaced and related patterns not included
 in the pattern lists xxxii
 Repetition and termination of patterns xliii
 Line patterns xlvi

Faunal ornament xlvi

 Organization and stance xlvi

 Body type xlvi

 Head type xlvi

Figural ornament xlvi

CHAPTER V. DATING METHODS xlvii

 Inscriptions xlvii

 Associations xlvii

 Historical contexts xlvii

 Typology and style xlvii

Discussion xlvii

CHAPTER VI. EPIGRAPHY xlix

LIST OF REFERENCES l

LIST OF FIGURES

Figure 1 Cross-shaft Shapes xv
Figure 2 Cross Shapes and Arm Types xvi
Figure 3 Ringed or Infilled Cross-head Shapes xvii
Figure 4 Tombs and Grave-markers xviii
Figure 5 Hogback Types – i xix
Figure 6 Hogback Types – ii xx
Figure 7 Hogbacks: Tegulation Types xxi
Figure 8 Techniques of Carving xxiii
Figure 9 Mouldings xxiv
Figure 10 Scroll Organization xxv
Figure 11 Leaves xxvi
Figure 12 Leaf Compositions xxvii
Figure 13 Berry Bunches xxvii
Figure 14 Complete Interlace Patterns xxx
Figure 15 Turned Patterns xxxiii
Figure 16 Complete and Turned Patterns with Breaks, V-bends and
 Included U-bend Terminals xxxiv
Figure 17 Complete and Turned Patterns with Added Outside
 Strands or Diagonals Added through the Element xxxv
Figure 18 Spiralled and Surrounded Patterns xxxvi
Figure 19 Encircled Patterns xxxvii
Figure 20 Other Interlace Complexities xxxviii
Figure 21 Half Patterns xxxix
Figure 22 Half Patterns with Outside Strands or Added Diagonal xl
Figure 23 Simple Patterns xli
Figure 24 Closed Circuit Patterns xlii
Figure 25 Interlaced and Related Patterns not included in Patterns Lists, I xliv
Figure 26 Interlaced and Related Patterns not included in Patterns Lists, II xlv
Figure 27 Line Patterns xlv
Figure 28 Runes: System of Transliteration xlix

By Gwenda Adcock and Yvonne Brown: figs. 14–25 and 27
By Yvonne Brown: figs. 2, 3, 9–11, 13 and 26
By Keith McBarron: figs. 1, 4–8 and 12

CHAPTER I

FORM OF CATALOGUE ENTRIES

The sculpture is described in county units according to the pre-1974 county boundaries.[4] Regardless of where the sculpture is now, pieces of known provenance are listed alphabetically under this provenance; stones of unknown provenance but now in collections within the county under review are listed at the end of each county catalogue.

Where there is more than one piece from a site, the pieces are numbered consecutively in the following categories: crosses; slabs, upright and recumbent; other types of funerary monument such as sarcophagi or hog-backs; architectural sculpture and church furnishings; fragments which cannot be attributed to any category with certainty.

Lost but illustrated stones are kept within these categories; those lost and unillustrated are listed in Appendix C. Appendix A lists stones of the Saxo-Norman overlap period, Appendix B stones wrongly associated with the pre-Conquest period, and Appendix D sundials presumed to be of pre-Conquest date.

Each entry or group of entries is headed by the name of the site of discovery with its National Grid Reference and (when applicable) the dedication of the church. The entry opens with the numbered type of monument, followed by *present location* and *evidence for discovery*.

Measurements are given in centimetres and inches and in the following terms:

UPRIGHT MONUMENT: height, H., (measured from ground) × width, W., (broadest or principal face) × depth, D.

RECUMBENT MONUMENT: length, L., × width (maximum width when viewed from above) × depth (thick-ness measured from ground). If original position of stone doubtful, height generally used.

The *stone type* is given in as precise or as general terms as are appropriate for the locality. In those places where the local sandstones are the commonest medium for sculpture, it has proved impossible to assign them to individual quarries. The *present condition* of each piece is noted, since this could be valuable for future reference.

Description of the stones is given in the following order:

UPRIGHT MONUMENT: A, the principal face, i.e. the west face when *in situ*, or one of the broad faces when not. The remaining faces are B, C and D, moving anti-clockwise around the monument. The faces are called A(broad), B (narrow) etc., where this is appropriate. If the horizontal faces of the stone are described, these are assigned the letters E(top) and F(bottom). Description starts at the top of each face, and when subdivided, each panel is numbered (i, ii, iii etc.). Architectural imposts and friezes are labelled A(long), B(narrow), etc.

RECUMBENT MONUMENT: several types have more than four carved faces; the terminology used to describe the parts is found in the classification of monuments (p. xiv). The top, roof, or upper surface, A, is described first, aided by the standard terminology of, e.g. crown, ridge, gable; then the sides, B, C, D and E, are described, moving anti-clockwise and starting with one of the long sides. These faces are called (long) and (end) as appropriate. For hogbacks, the ridge and end-beasts are described first, then the sides, labelled A(long), B(end) etc., as appropriate.

The description is followed by a *discussion* and *date,* and the entry is concluded by *references,* arranged in chronological order of publication. Some sites with a group of entries warrant a list of general references as well as one for individual stones. The list of general references appears as a footnote at the head of the group of entries.

4. Clearly these geographical units do not correspond with political or ecclesiastical boundaries in the Anglo-Saxon period. Nevertheless, since the amount of material precludes publication in a single volume, some subdivision of the country is necessary. As can be seen from note 1, the system adopted for England is comparable with the European corpora.

CHAPTER II

CLASSIFICATION OF FORMS AND SHAPES OF MONUMENTS

The classification of sculpture adopted in this corpus is set out below in the order in which the types appear in each site entry. Regional variations of the basic types will be illustrated, when necessary, in the appropriate volumes. A table including monument types is produced volume by volume.

FREE-STANDING CROSSES
(Figs. 1–3)

Many crosses are too fragmentary for the original height to be calculated accurately. However, when complete, they range from those of monumental proportions, *c.* 544 cm (216 in), to those conceived on a scale as small as *c.* 86 cm (34 in). Nevertheless, scale has not been made a basis for classification since it is rarely calculable. The crosses are described and classified according to the shape of the shaft and the shape of the head.

CROSS-SHAFTS (Fig. 1)

These may be divided into two groups, ANGULAR and ROUND.

ANGULAR (Fig. 1, a–e): these are differentiated by the terms squarish, rectangular, and slab-like. Distinctive sub-types are the *stepped shaft* (Fig. 1, c); the *shouldered shaft* (Fig. 1, d); and the *collared shaft* (Fig. 1, e).

ROUND (Fig. 1, f–h): the *columnar shaft* is cylindrical throughout its height (Fig. 1, f). *Round-shaft derivatives* are shafts with two sections, of which the upper part is angular while the lower part can be round or sub-rectangular (Fig. 1, g–h). The division between the sections can be marked by a *swag* (Fig. 1, g), and/or a *collar* (Fig. 1, h).

CROSS-HEADS (Fig. 2)

Three elements determine the shape of the cross-head:
The form of the end of the arm (arm-terminal)
The form of the arm-pit
The proportion of the block (square, rectangular or circular), from which the head is carved

The classification in Fig. 2 is based on the forms of the arm-terminals and arm-pits only. In some cruder pieces a cross-head incorporates different arm types. The method of classification set out in Fig. 2 allows the arms to be described separately where necessary, and also allows the description of a fragment without assuming the shape of the whole head.

In addition, the space between the arms on some cross-heads and slabs is filled or partly filled by a circular feature (Fig. 3). Here all are shown attached to a cross of type A1, but in practice they occur on various forms of cross. In the catalogue entries these circular features are described as follows:

Ring a: a ring joins the arms near the arm-pit.
Ring b: a ring joins the arm-terminals.
Circle: a ring is superimposed, joining but also over-riding the arms.
Billet: the arm-pits are filled with small plates or rolls.
Plate: the whole space between the edge of the ring and the arm-pit is filled.

Two or more of these features can be combined in one head; and any of the above forms can be carved on a solid rounded block, for which Nash-Williams's term 'disk-head' has been adopted (Nash-Williams 1950, pls. 37–9).

TOMBS AND GRAVE-MARKERS
(Figs. 4–7)

a and bi–iii. *Slabs.* Upright and recumbent slabs are considered together since it is not always possible to distinguish between them (Fig. 4, a). It seems that some slabs stood upright against, or were set into, a church wall, but there appears to be no formal difference between these and recumbent slabs. Forms of slabs will, in general, be described in commonly accepted terms: square, round-headed, square-headed, rectangular, half-round, tapering and coped (Fig. 4, bi–iii). Sometimes it is possible to be certain that these slabs were clearly either grave-markers or grave-covers, and where this is known this information is given. The classification of cross-head shapes (Fig. 2) applies also to crosses carved or incised on these slabs.

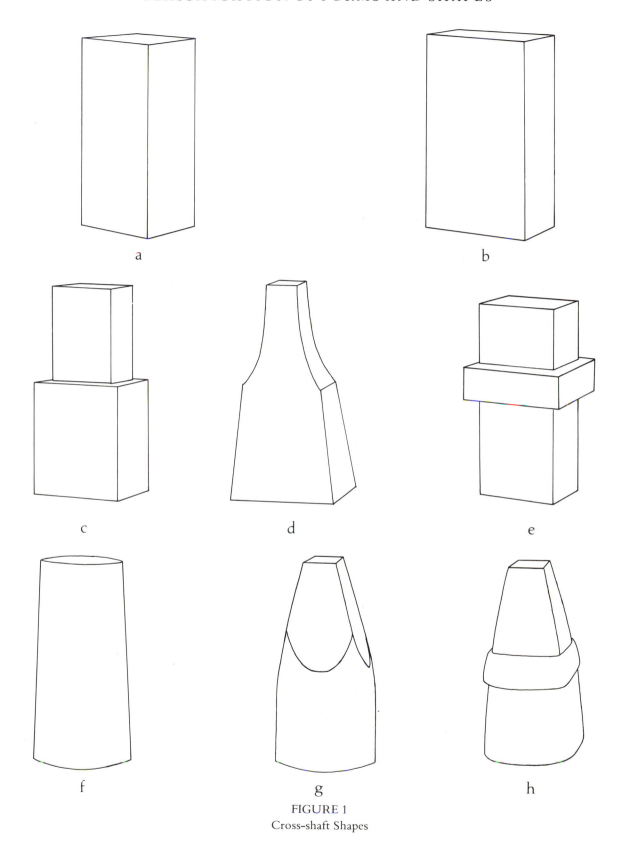

FIGURE 1
Cross-shaft Shapes

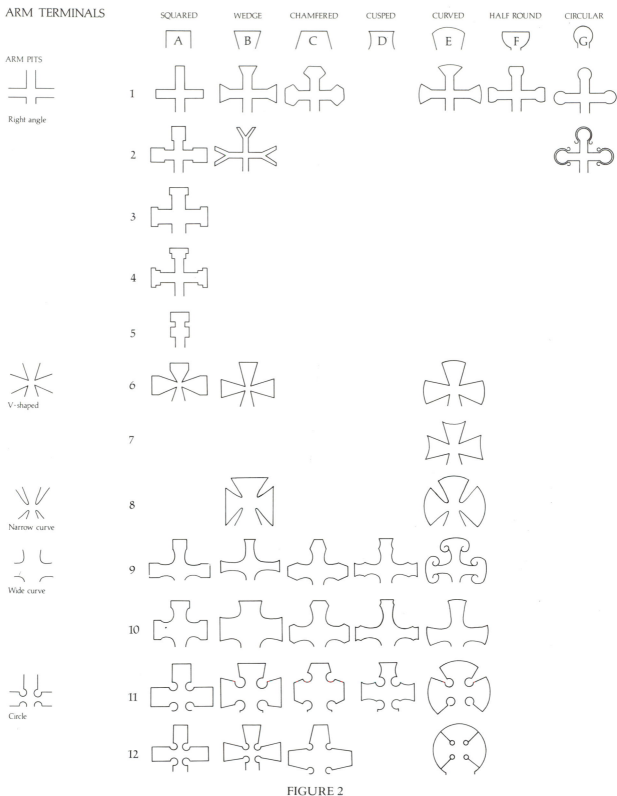

FIGURE 2
Cross Shapes and Arm Types

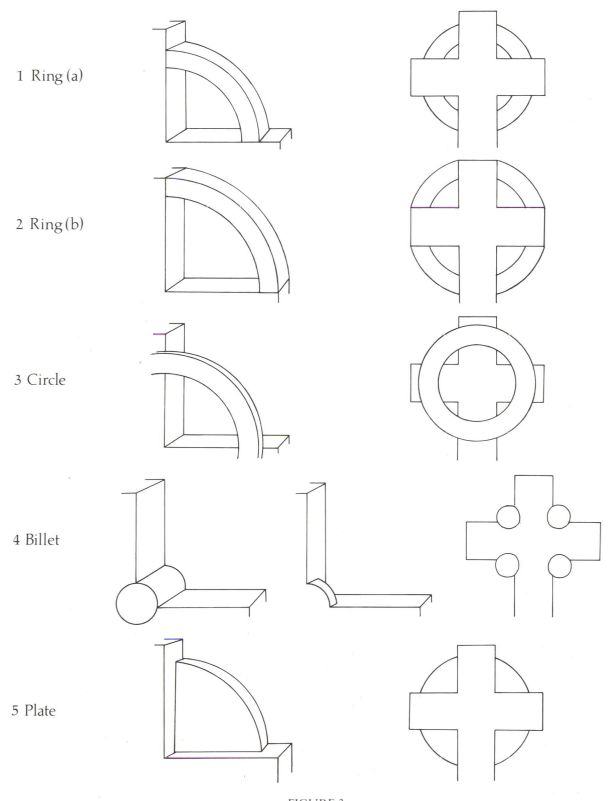

1 Ring (a)

2 Ring (b)

3 Circle

4 Billet

5 Plate

FIGURE 3
Ringed or Infilled Cross-head Shapes

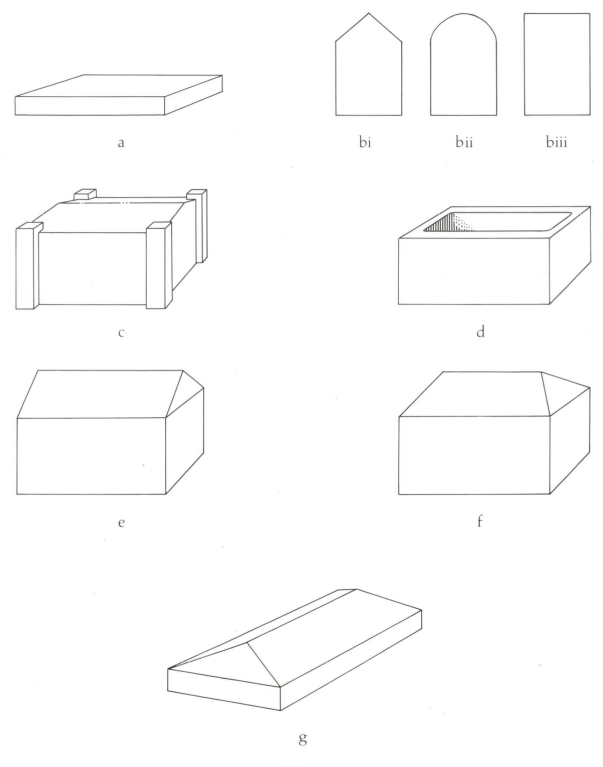

a

bi bii biii

c

d

e

f

g

FIGURE 4
Tombs and Grave-markers

FIGURE 5
Hogback Types – i

FIGURE 6
Hogback Types – ii

The more pretentious forms which are constructed to enclose the body above ground, or to give the impression of a house for the dead may all have derived from the Classical sarcophagus but have various Insular forms. They are distinguished thus (Fig. 4):

c. *Corner-post shrine,* where the slab sides are set into rectangular columns at the corners

d. *Coffin type,* where the receptacle is formed from a single hollowed-out block.

e and f. *Sarcophagus type,* where the monument is formed from a single house-shaped block with a gabled or hipped roof.

g. *Coped type,* where the 'roof' of the monument stands only just above ground level.

The distinctive type of monument which appears in areas of Scandinavian influence, *the Hogback,* is classified according to the terminology proposed by Lang (1967): a, panel type; b, pilaster type; c, niche type; d, extended niche type; e, dragonesque type; f, vestigial end beast type; g, illustrative type; h, scroll type; i, house type; j, wheel rim type; k, shrine type. Schematic illustrations are provided on Figs. 5–6 and their tegulation types on Fig. 7.

ARCHITECTURAL SCULPTURE AND CHURCH FURNISHINGS

Terminology follows accepted usage.

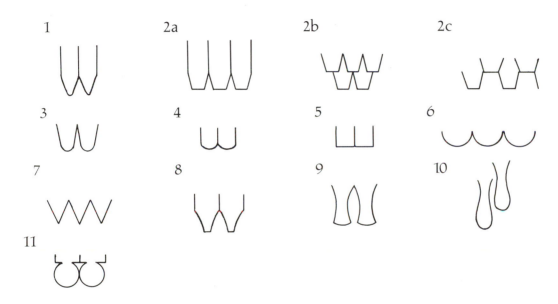

FIGURE 7

Hogbacks: Tegulation Types

CHAPTER III

TECHNIQUES OF CARVING

The tools of the Saxon carvers seem to have differed little from the standard tools in the Roman period, some of which are still in use today (Hodges 1964, fig. 22): walling hammers and picks; blunt-nosed and sharp points or punches; straight-edges and compasses; and wide-bladed and narrow-bladed chisels. Stones were sometimes lathe-turned, or occasionally drilled.

Parts which were not meant to be visible were dressed with rough, diagonal, scored lines. The more smoothly dressed parts were marked off by a fine point, as were laying-out lines for ornament. The surface of the stone was further finished by the use of a fine chisel and could be smoothed down to an almost polished surface.

The finished appearance of the carving techniques is described in the following terms:

Modelled Technique (Fig. 8, a–b). The relief details are deeply carved, the upper surface is rounded and the sides are chiselled straight with a flat smooth ground between them.

Humped Technique (Fig. 8, c). The relief details are not deeply carved, the rounded upper surface curves down to V or U-shaped grooves. The outlines are sometimes punch-marked.

Grooved Technique (Fig. 8, d). The details are formed simply by deep grooves cut from a flat surface, and a coarse tool is used which leaves an uneven surface. A variation of this technique occurs when the detail is punch-outlined, so that the marks of the tool do not form a continuous groove.

Incised Technique (Fig. 8, e). Ornamental details (usually interlace) are marked by broken incised lines.

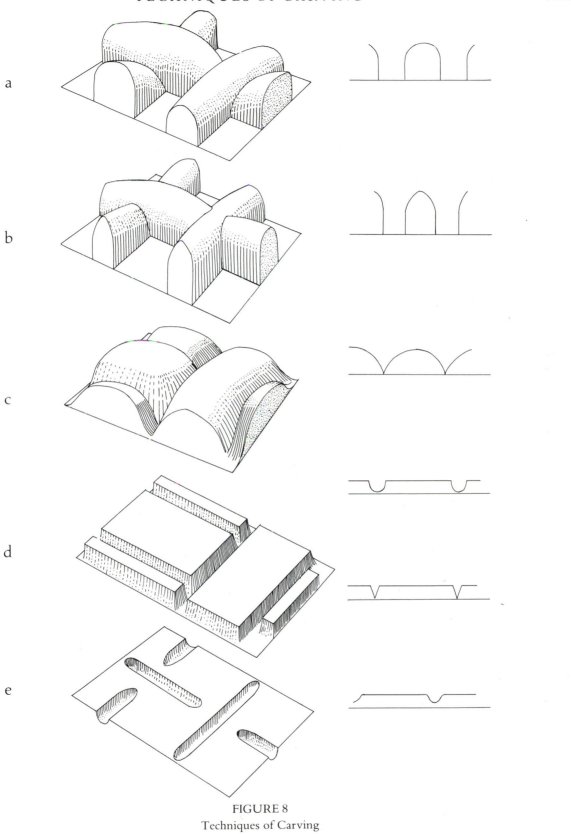

FIGURE 8
Techniques of Carving

CLASSIFICATION OF ORNAMENT

A table indicating the main types of ornament which appear on each piece of sculpture in a region is produced volume by volume.

MOULDINGS
(Fig. 9)

These with the exception of type d (Fig. 9) are relief frames used to outline the forms of monuments, or to outline and sub-divide fields of ornament. The most common are:

Flat-band moulding (Fig. 9, a)
Roll moulding (Fig. 9, b) and double roll moulding
Cable moulding (Fig. 9, c)
Grooved moulding (Fig. 9, d). A pseudo-moulding in which the outline is not raised above the surface of the stone. It appears in the same positions as relief mouldings.

Different mouldings found in combination give a more elaborate effect, and basic mouldings may be enriched by pellets. Some mouldings develop into architectural forms such as arcades and are described in these terms.

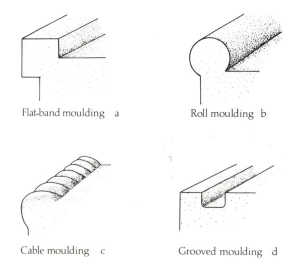

Flat-band moulding a Roll moulding b

Cable moulding c Grooved moulding d

FIGURE 9
Mouldings

PLANT-SCROLLS
(Fig. 10)

Plant-scrolls seem to be the distinctive form of ornament which was introduced into Anglo-Saxon England together with sculpture rather than derived from other media.[5] The theological significance of the vine develops from the text of St John's Gospel (*John* 15, 1–17) and it is adopted in both its simple and inhabited forms throughout the early Christian world (Toynbee and Ward Perkins 1950). Plant-scrolls in art retained a relationship with the botanical form in those countries where it was indigenous. In the British Isles, however, the varied and experimental forms often depart considerably from the botanical vine plant which would have been found in Classical originals, and there are few examples from Anglo-Saxon England which could be mistaken for continental work.

Nevertheless a simple classification which takes into account the organization of the main stems and the main types of leaves and berry bunches seems sufficient to characterize most pieces, and details such as whether the stems are incised or plain, together with the forms of the nodes and the nature of the carving, is provided under individual descriptions (Fig. 10).

LEAVES (Fig. 11)

The leaf types of plant-scrolls on sculpture are sometimes difficult to characterize because of their worn condition. Only occasionally can the fine veins, which exist in the best carvings, be seen. Differences in scale have been ignored in Fig. 11, although reference to size may occur in descriptions. There are considerable minor differences. Many of these differences may however be caused by the angle at which the leaves are set to the stem, or result from the fact that the tip is curved or straight. The following list seems to cover the main types. It should be noted, however, that all types are subject to occasional variation, the central line being raised or incised, or the centre of a leaf being raised or scooped. Such features appear as types only if they occur often enough to constitute a significant group.

5. See Kitzinger 1936. Brøndsted saw this motif as of paramount chronological importance (Brøndsted 1924), and there are both chronological and regional variations. In this series such variety will be considered in the area discussions in each volume.

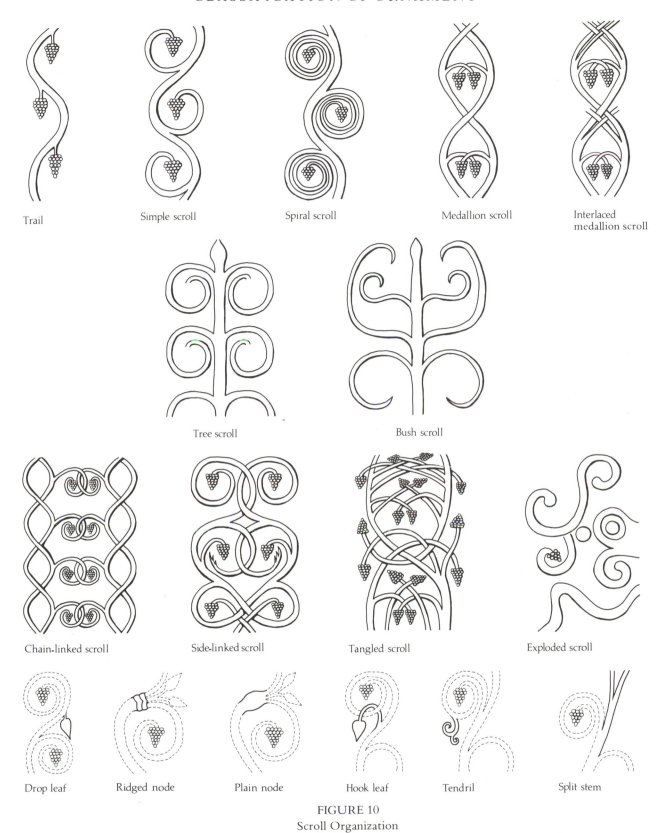

Trail

Simple scroll

Spiral scroll

Medallion scroll

Interlaced
medallion scroll

Tree scroll

Bush scroll

Chain-linked scroll

Side-linked scroll

Tangled scroll

Exploded scroll

Drop leaf

Ridged node

Plain node

Hook leaf

Tendril

Split stem

FIGURE 10
Scroll Organization

		VEINED	PLAIN	SCOOPED OR RAISED CENTRES
LEAVES	Tree			
	Split			
	Half moon			
	Serrated			
	Triangular			
	Curling			
	Heart-shaped			
	Heart-shaped Lobed			
	Elongated			
	Pointed			
	Pointed/Lobed			
	Oval			
	Round			

FIGURE 11
Leaves

(a) Paired leaves

(b) Triple leaves

(c) Leaves with bud or fruit

(d) Leaf-flowers or seed pods

(e) Buds

(f) Leaf-whorl

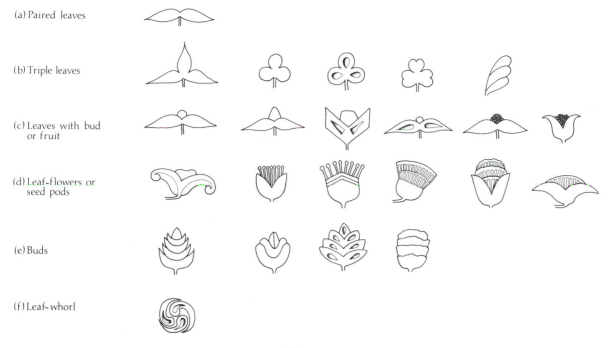

FIGURE 12
Leaf Compositions

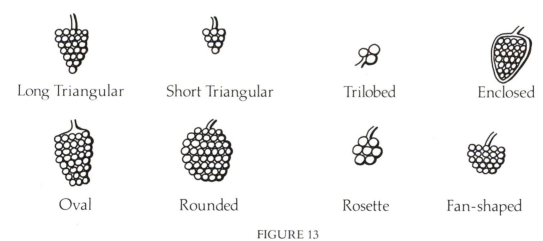

Long Triangular Short Triangular Trilobed Enclosed

Oval Rounded Rosette Fan-shaped

FIGURE 13
Berry Bunches

LEAF COMPOSITIONS (Fig. 12)

Leaves combined in pairs or groups are described in terms of the leaf types. However, there are some composite plant forms which have distinctive features. These have not been divided into rigid categories, but since there are regional and chronological variations, typical forms have been distinguished as follows: leaves can frame berries or buds and can be up-pointed or horizontal, triangular or angular. Sometimes the leaves are more like sheaths framing berries, stamens, flowers, or seeds. Distinctive are the leaf-flower, sometimes known as the Byzantine blossom, the leaf-whorl, and elements best described as composite buds.

FRUIT (Fig. 13)

Fruit bunches are the most difficult to define of any element in the plant-scroll and in some places, indeed, it is impossible to tell whether a feature is a fruit or a flower. The classification in Fig. 13 has been used whenever possible.

INTERLACE
(Figs. 14–26)

Interlace or plait is the most common form of ornament encountered on Anglo-Saxon sculpture and its variety and experimentalism make it difficult to categorize. Nevertheless identical patterns exist and it is apparent that there must have been formal principles underlying its construction and, in consequence, the possibility of formal grouping.

Most scholars wishing to define interlace types use the classification devised by Allen (1903). However, more recently an alternative theory for the construction and classification of interlace has been proposed in an unpublished M.Phil. thesis of the University of Durham by Gwenda Adcock. It will be referred to as Adcock 1974; as its conclusions are made use of and its terminology here adopted, it is necessary to summarize it.

Adcock built upon the work of Allen and of Bain (1951), and all saw that groupings or categories of this form of ornament must be consistent with the constructional principles which lie behind it and that these depend, to a certain extent, on what is believed to be the possible origin of the ornament.

Allen (1903, 142–3) maintained that, although 'mechanical necessity' such as plaiting, knitting or weaving could give rise to interlaced patterns, the fact remained that the 'plait was not used for purposes of decoration until after the introduction of Christianity into this country', and that it was not found in combination with the divergent spiral on metalwork of the pagan period. He therefore supposed that the Christian sculptor may have seen interlace patterns or plait-work on early manuscripts and developed this form of ornament with the geometric background aids such as he would have used for the production of curvilinear art.

Allen supposed that, once the visual idea had been grasped, interlace could develop from plain plait-work, in which the over and under strands are set out on a grid of opposing diagonals at 45° to the picture plane, and evenly spaced. All the bends along each of the two vertical edges are broken and bent round to form a right angle (Allen 1903, figs. 198–200). An interlace differs from a plain plait in that threads or strands may turn internally instead of making a continuous progression downwards. A turn means that a crossing is avoided and this is called a 'break'. Allen did not discuss the intervals between his crossings nor the width of strands – both of which can give individuality to patterns. The many individual patterns his theory produced mean that his work for reference purposes is over-complicated, and patterns which clearly belong to the same 'family' are widely separated in their numbering.

In the Anglo-Saxon context it is not true to say that interlace appears only with the acceptance of Christianity, although it has been plausibly argued that it develops in a period (the seventh century) after migration and new settlements had brought the Germanic peoples into close contact with the traditions of the Classical world (Åberg 1943). Fine line ornament with crossing strands and linked 'elements' is manifest in the simple patterns on the Crundale sword and on the Sutton Hoo brooches (Haseloff 1958, pl. 8), and a different type of closely packed strands of crossing ornament is found in the seventh century on metalwork as far separated as Kent and the Mote of Mark. These ornamental essays may represent a response to contact with plaited designs from the Mediterranean world, and filigree such as is found on the Crundale material would have been manipulated in its three dimensional form (Haseloff 1958, pl. 8). Adcock (1974), whilst considering the metalwork and possible inspiration from Roman or Coptic art, convincingly discusses these as 'decorative parallels' which have little in common with the complex patterns found on later manuscripts and sculpture. She sees the development of interlace through the use of 'made' patterns in leather, metal, or woven strands. This use of three-dimensional models could have been extended to templates, which she sees also as part of the constructional aids in interlace (Adcock 1974, 35–42). Nevertheless whatever the origin of the idea of interlace and whatever the necessary aids for ignorant or incompetent craftsmen, even the competent craftsmen needed a background mechanism to assist in working out complex patterns.

R. L. S. Bruce-Mitford, in discussing the construction of interlace in the Lindisfarne Gospels, noted on the reverse of folios 26v, 139r and 210v that a square grid had

been marked out in dry point, and on the reverse of fol. 2v there were small dots along the edge of the pattern which could be joined to make a grid of squares (Bruce-Mitford 1960, 221–31). Adcock (1974, 7–15) analysed this grid further and applied it to other manuscripts, such as Durham A. II. 10, and to early Northumbrian sculpture.[6]

CONSTRUCTIONAL AIDS

The *square grid* has lines at right angles and parallel to the edge of the interlace strands, with grid crossings not under the crossings of the strands, but under the holes or voids between them.

These voids are called *hole points* and the grid lines seem invariably to cross in every second hole.

Square Grid *Hole Points*

The distance between the lines of a square grid measured either vertically or horizontally along a line of hole points or crossing points gives the *unit measure* used by the craftsman.

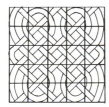

Unit Measure

Allen, using a *diagonal grid*, drew his diagonals from corner to corner and presumed that the diagonal formed the medial lines of strands. Adcock found that the edges of the strands are the factors to be related to the *crossing points*. The strands cross on the grid lines and are equidistant from the grid crossings. The pointed loops of interlace can be neatly turned by following the grid lines to make an angle of 90°.

6. E. J. Thiel (1970) has made a detailed analysis of interlace grids in Insular manuscript layouts (see also Lexow 1921–2).

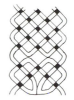 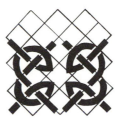

Diagonal Grid *Crossing Points*

Because the points of *asymmetrical loops* fit neatly into the boxing of the grid these are called *box points*.

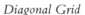

Asymmetrical Loops

Box Points

Despite the additional versatility in producing geometric patterns which this use of a grid provides for both manuscript painting and sculpture Adcock feels that both conform to the fundamental rules of woven interlace. Her six 'basic patterns' (Fig. 14) which all have four strands are derived from the principles of 'made' interlace. 'Four strands are a natural number to control and plait using both hands and opposing movements' (Adcock 1974, 54).

The 'basic patterns' for sculpture are also '*mirror image*' patterns and can be said to form the complete unit rather than half of this, which could be doubled. It is proposed therefore to call her basic patterns '*complete patterns*'.

Mirror Image Pattern

THE PATTERN LISTS

COMPLETE PATTERNS (Fig. 14)

Six complete patterns are formed from six distinctive elements:

The asymmetrical loop with three ways of extending the curved side of the loop:

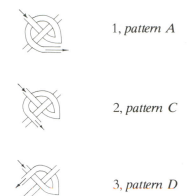 1, *pattern A*

2, *pattern C*

 3, *pattern D*

The returned asymmetrical loop:

4, *pattern E*

The symmetrical loop:

 5, *pattern F*

The U-bend:[7]

 6, *pattern B*

7. This, as Adcock notes (1974, 54), is also the main element for Allen (1903, lv).

Strands and Cords
The threads necessary to form interlace, based on these six elements, are called *strands*, and in the simplest form these are *diagonalling* strands (the direction of all strands in plain plait),

Strand Diagonalling Strand

but in interlace these cross the *working* strands which form the pattern elements. Sometimes in interlace patterns there are strands lying outside those which form the elements or diagonals and these are called *outside* strands.

Working Strand Outside Strand

It should be remembered that both plain plait and interlace patterns exist in sculpture and sometimes a pattern is described as having a number of *cords*. This term refers only to the structure underlying interlace. There is always one more cord than the number of crossings and the *cord count* may be made along the length or breadth of an interlace.

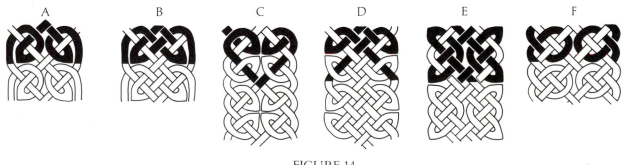

FIGURE 14
Complete Interlace Patterns

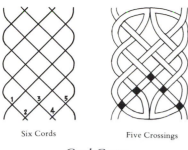

Six Cords Five Crossings

Cord Count

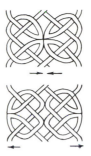
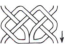

Turned Patterns

All patterns form their complete expression in *registers* in which all the strands return to their original position so that the pattern can be repeated.

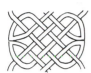

Register

A register is composed of one, two, or four *pattern units* or *elements*.

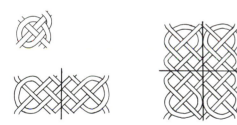

Pattern Units

PATTERN VARIATIONS (Figs. 15–24)
In interlace, variations are produced by manipulating the complete patterns.

Turned patterns (Fig. 15) are produced by turning single or paired elements at an angle of 90° or 180° from their position in the complete pattern. The possibility of variation is more restricted in some pattern groups than in others, as elements may only be turned if the strands in the new position can move to form a terminal or into the next register. A 90° turn usually alters the cord count of a pattern.

Complete and turned patterns with breaks, V-bends and included U-bend terminals (Fig. 16) alter a pattern superficially. The possibilities of variation are enormous and only a few possibilities are shown.

Complete and turned patterns with added outside strands or diagonals added through the element (Fig. 17). Some patterns already include one or other of these variations as a necessary element in pattern formation.

Spiralled and surrounded patterns (Fig. 18). A spiralled element is produced when the strand is carried round the element for a second time, as Fig. 18, Aa. Surrounding an element or group of elements by a second strand as in Fig. 18, cb, creates a similar impression to spiralling. These variations are therefore considered together.

 Few mirror image patterns with a surrounded element exist and in some of these only the terminal unit has survived, leaving it inconclusive as to whether the surround in these was an elaborate form of terminal or was repeated throughout the pattern.

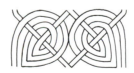 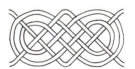

Spiralled Pattern *Surrounded Pattern*

An encircled pattern (Fig. 19) is a pattern register which includes a separate strand forming an unbroken circle through it, or with the strands from the pattern itself forming a circle which may, however, be broken in one or two places (Fig. 19, C, D). An encircled pattern in which the ring or circle is threaded through four outward pointing pattern C elements is commonly known as a *ring-knot* (Fig. 19, C). This term is also sometimes used to describe analogous motifs, in which one or more concentric free rings are threaded through various types of closed circuit loops (see below under *Closed circuit patterns*, Fig. 24, B, C).

Encircled Pattern *Ring-knot*

Other complexities (Fig. 20). All patterns may be expanded, either by parting the paired elements and elaborating the diagonals; or by bringing four elements abreast. A pattern with central twists, surrounded elements and outside strands, exists (Fig. 20, F); this surrounded element is unique. Central twists are used occasionally, but are more common in manuscript patterns.

Half patterns (Fig. 21) are one side only of a complete pattern. These are mainly two-strand, four-cord patterns. Pattern D of this type can include other types of variation already discussed. One (Fig 21, D) is a combination of a D and F loop. Half pattern E tends to have a higher cord count than other groups.

Half Patterns

Half patterns with outside strands or added diagonal (Fig. 22). This is a large and varied group, including four-strand, six-cord patterns, and the pattern can be changed where the outside strands cross the working or diagonal strand.

Simple patterns (Fig. 23) are formed from elements pushed together so that they form their own diagonals. Simple pattern E is commonly known as the Stafford Knot, and simple pattern F as the Carrick Bend. The drawing below shows each of these beneath the pattern units from which they are derived.

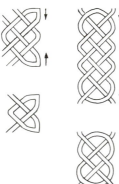

Simple Patterns

Closed circuit patterns (Fig. 24) are formed from diagonals through closed circuit strands, are easy to construct, and when repeated give an impression of interlace, although they are not, in fact, true interlace (see pp. xxviii–xxx). They are placed on Fig. 24 in the column of the pattern they most resemble. In the case of D and F there is an obvious link with the elements which define those types in continuous interlace. In A, however, where one or two free rings are crossed by long diagonal strands, there is no organic relationship with pattern A elements. In C, which is also based on the asymmetrical loop, the free rings bisect closed circuit pointed or split loops. In B, the closed circuit loop terminals here are clearly related to the U-bend. The circling motifs listed under B and C may also be described as *ring-knots* (see above under *Encircled pattern*).

Closed Circuit Strand

INTERLACED AND RELATED PATTERNS NOT INCLUDED IN THE PATTERN LISTS (Figs. 25–6)

1. Circular patterns (Fig. 25, Ci–iv) are found in the central roundels of some cross-heads. Not all have been included as some are too worn to work out.
2. *Plait* or *plain plait*. See p. xxviii.
3. Return-loop patterns (Fig. 25, Bvi–vii)
4. Square panels divided diagonally (Fig. 25, Ai–iii, v); all but Aii, the split plait, are rare.
5. Straight line lacing patterns (Fig. 25, Cv–vii)
6. *Triquetra* patterns (Fig. 25, Aiv and Bi–iv) cannot be constructed on a square grid, and so are only found on spandrels and circular and square panels. Fig. 25, Biii, is an elaboration of the motif. Fig. 25, Aiv, uses both the triquetra and a similar four-looped pattern.
7. Twisted and linked patterns (Fig. 26 and p. xliii). Some twisted designs, such as Fig. 26, Bi–iv, can be drawn on a square grid, but others (Fig. 26, Bvi and Ci–iii) are less orthodox. The strands are twisted rather than laced in all these patterns but several are made of closed circuit links.

 Ring-twist is a name commonly given to a series of rings connected by long diagonals (Fig. 26, Civ). Various forms of *ring-chain* also come under the heading: simple ring-chain (Fig. 26, Cvi); bar-type ring-chain (Fig. 26, Cv); and vertebral ring-chain (Fig. 26, Cvii), which can be median-incised.

FIGURE 15
Turned Patterns

FIGURE 16
Complete and Turned Patterns with Breaks, V–bends and Included U–bend Terminals

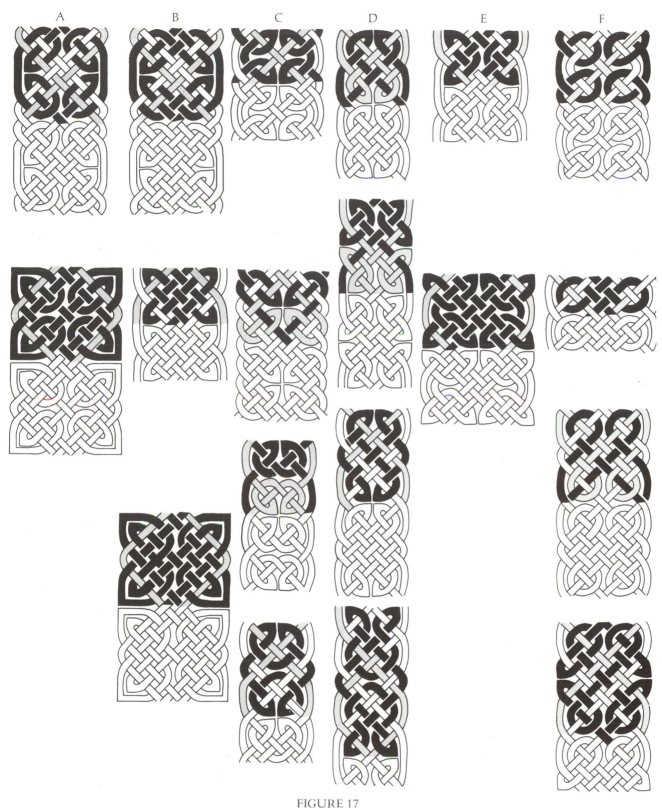

FIGURE 17

Complete and Turned Patterns with Added Outside Strands or Diagonals Added through the Element

A

a

C D

a a

F

a

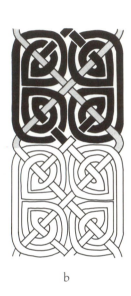

b

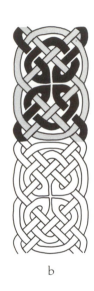

b

FIGURE 18
Spiralled and Surrounded Patterns

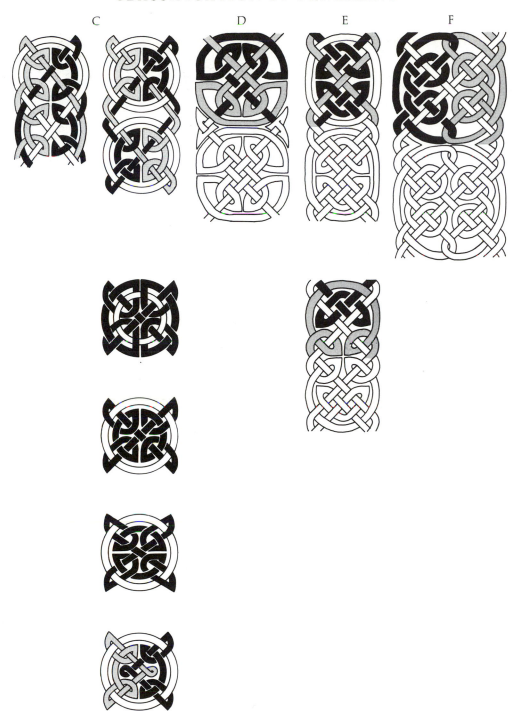

FIGURE 19
Encircled Patterns

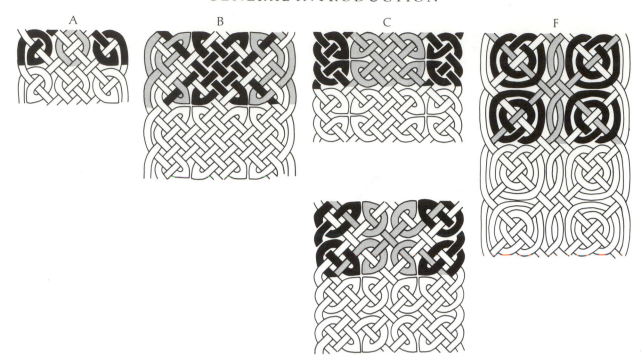

FIGURE 20
Other Interlace Complexities

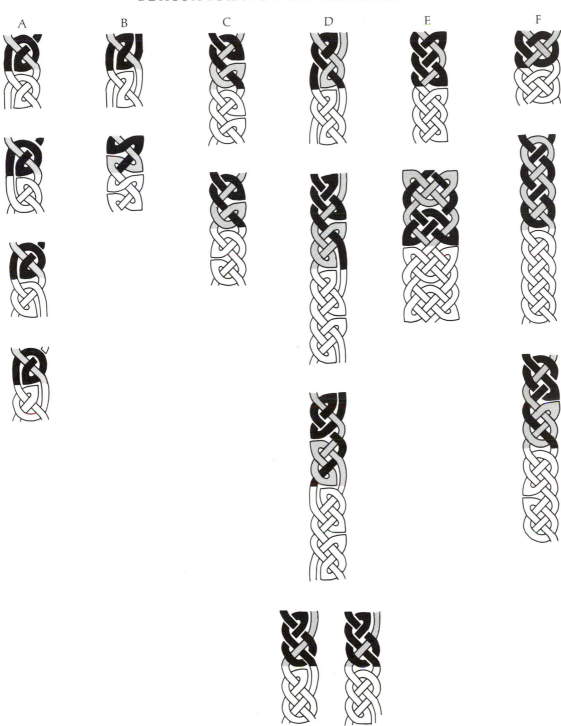

FIGURE 21
Half Patterns

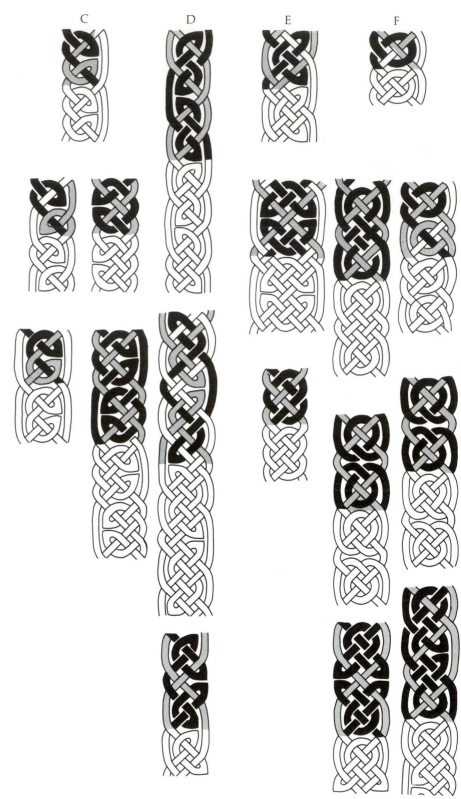

FIGURE 22
Half Patterns with Outside Strands or Added Diagonal

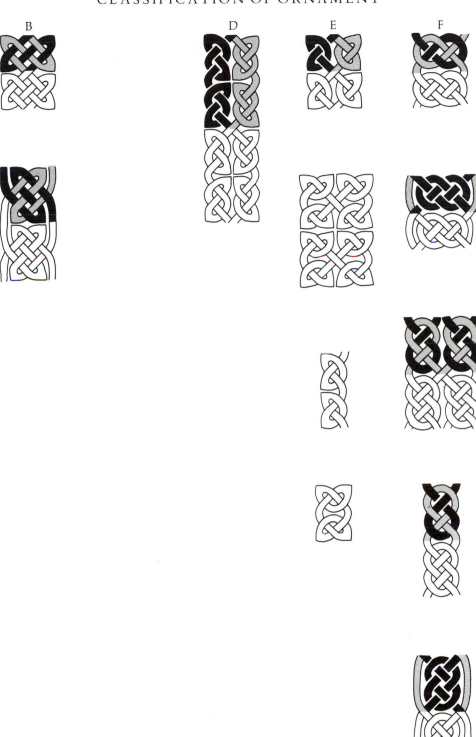

FIGURE 23
Simple Patterns

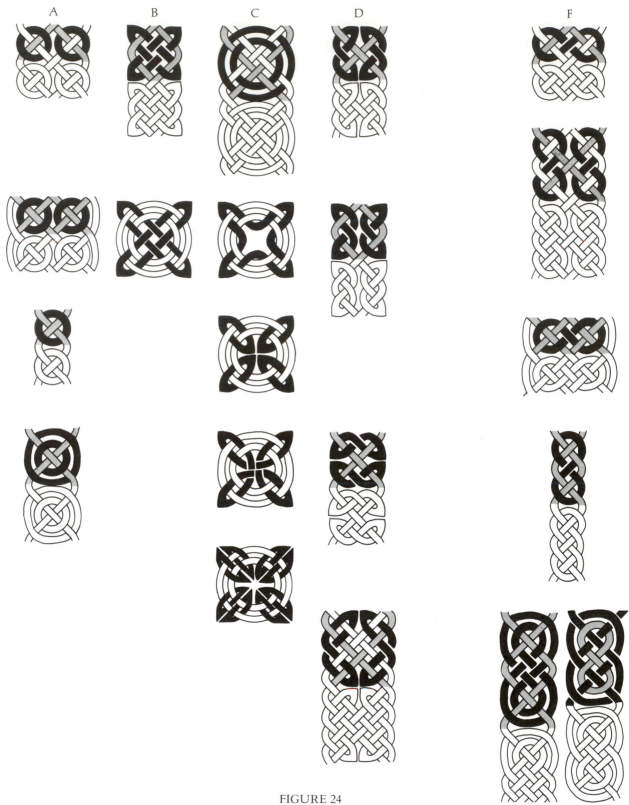

FIGURE 24
Closed Circuit Patterns

8. *Unpinned loop* patterns (Fig. 26, Di–iv, and p. xxxii); Fig. 26, Div, can also be called *Como-braid*.

9. *V–bend* patterns (Fig. 26, Ai–vi, and p. xxxii) are simplifications of patterns with other elements and are thus akin to closed circuit patterns. Fig. 26, Av, is close to some twisted patterns (Fig. 26, Bvi and Ci), but because it forms a diagonal through itself it has been classed with the V-bend patterns. The pattern on Fig. 26, Avi, with its split strands, is rare.

REPETITION AND TERMINATION OF PATTERNS

REPETITION

All these registers of patterns can be repeated. Normally a panel of interlace will have a continuous pattern scaled so that the same pattern continues through several registers to fill the distance available. Sometimes, however, registers of pattern are widely spaced and linked by strands independently of the grid. This is called a *glide*.

Glide

Sometimes a space is filled with different pattern units with the same strand positions at the end of each register so that the pattern units may then change. This is called a *changing pattern*.

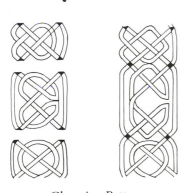

Changing Pattern

TERMINALS

Any pattern of carefully constructed interlace will join the strand ends with a *terminal*. This terminal can be included in a panel at the end of each pattern register.

(This reduces the complexity of many crossings.) Sometimes the pattern terminates only at the end of the first and last registers within or outside the pattern space, and in this form of terminal, the conclusion can be made by bar or by joining paired, crossed or alternate strands.

Included Terminal *Bar Terminal*

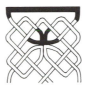 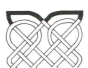

Paired Joining *Cross Joining*

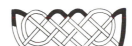

Alternate Joining

DUPLICATION AND DECORATION OF STRANDS

Finally, complexity and enrichment can be provided for a pattern by the use of *double strands*, where two strands move in the same direction , and never cross in a register. The strand itself may be decorated by incised grooves along its centre line (*median-incised*), or by rows of pellets.

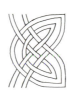

Double Strand *Median-incised Groove*

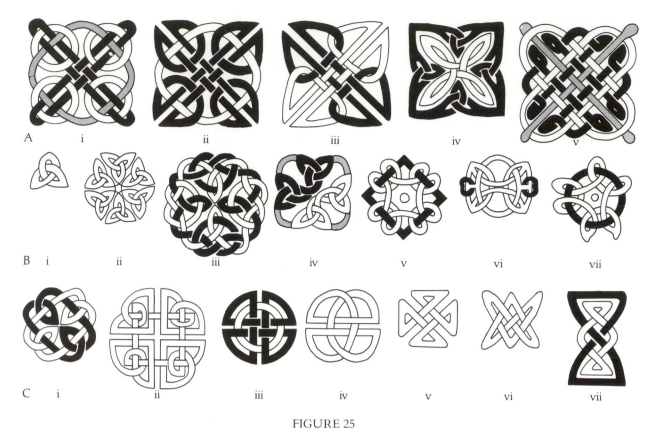

FIGURE 25
Interlaced and Related Patterns not included in Pattern Lists, I

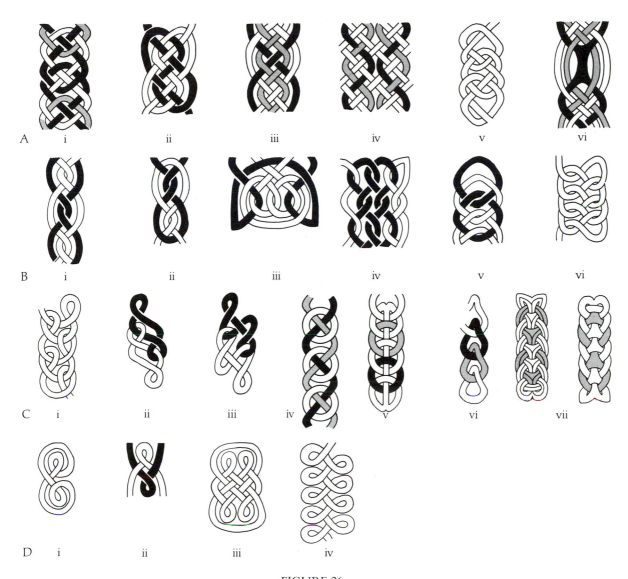

FIGURE 26
Interlaced and Related Patterns not included in Pattern Lists, II

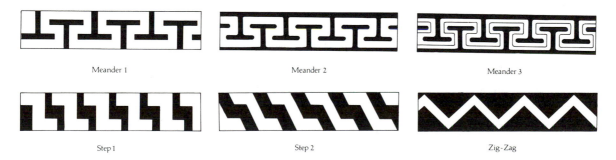

Meander 1

Meander 2

Meander 3

Step 1

Step 2

Zig-Zag

FIGURE 27
Line Patterns

LINE PATTERNS

The straight line patterns known as meander, step and zig-zag patterns are set out in Fig. 27. More elaborate straight line, key or fret patterns are few and for these the numbering system used by Allen (1903) has been retained.

FAUNAL ORNAMENT

The classification and analyses of this type of ornament present special difficulties since the birds and beasts can reflect not only Germanic and Insular models, but also Classical ones. These last are more varied and realistic than those found in the indigenous traditions of metalwork, and the creatures they produce do not form into the repetitive groups of Pictish symbols. One cannot classify rigidly nor use the terminology traditional in ornamental metalwork classification of the period. However, terms applied in other media such as 'Style II' type, 'Trewhiddle' type or 'Jellinge' type are used in discussion. A table including animal types is produced volume by volume.

Animal and birds are described as consistently as possible in relation to: organization and stance; body type; and head type.

ORGANIZATION AND STANCE

Many of the terms used to describe these factors are common words or phrases such as biting, or forward-looking, which need no further definition, and these are not included in the following list:

Addorsed. Paired animals, back to back
Affronted. Paired animals, bodies facing, heads turned back
Confronted. Paired animals, heads and bodies facing
Crouching. Back legs or both fore and back legs folded beneath
Enlaced. One or two extensions from, e.g., tail or ear, cross or form knot.
Enmeshed. Extensions cross and entwine the animal.
Extension. Strand which extends from tongue, lips, ears, head, tail or feet
Fettered. Animal entwined by strand which is not an extension of itself
Head, backward thrown. Head thrown back so far that it is inverted over body

Head, down reaching. Head bent forward as far as, or farther than, feet
Interlocked. Animal intertwined with bodies and limbs of adjacent beasts
Kicking. One or two back legs raised
Kneeling. Forelegs folded beneath, with back legs straight
Prancing. One front leg raised
Rampant. One hind leg on ground and one raised; both forelegs raised, one above the other
Rearing. Two front legs raised
Sprawling. Viewed from above with legs outstretched

BODY TYPE

Biped. Creature with two forelegs, tail and sometimes wings
Profile animal. Four-legged creature shown in profile so that only one front and one back leg visible
Quadruped. Creatures with all four legs shown, including those that are winged or centaur-like
Ribbon animal. Snake-like creature with no legs and with body of uniform width

HEAD TYPE

Animal heads are described in simple terms of likeness. *Birds* are not easily assignable to species but can be described in such terms.
Canine. With pointed ears, long muzzles usually squared off and sometimes with fangs, generally in profile
Cat-like, squirrel-like or *reptilian* are also used.
Leonine. With rounded heads and ears and often with mane, full-face or in profile

FIGURAL ORNAMENT

Figural carvings, whether of individuals or groups, are first described in terms of composition and position. Each figure is then described in detail and, if possible, identified. There is not an extensive repertoire of iconographic types and many individual figures have to be described as Saint (haloed without a book); Saint or Evangelist (haloed and with a book); Christ in Majesty etc. A table including figure types is produced volume by volume. The nature and treatment of drapery, the mode of depiction of facial type, scale, and the use of architectural backgrounds have all been found useful criteria in grouping figural sculptures.

CHAPTER V

DATING METHODS

So far no analytical method has been devised to date carved stone in absolute terms. One therefore depends upon a hierarchy of traditional dating methods. These are, in order of accuracy:

INSCRIPTIONS

a, which directly refer to the carving and its original position, as, for example, the dedication stones from Jarrow or Deerhurst churches;
b, which associate the sculpture with a specific date in the life of an historic person;
c, which associate sculpture with an historic person thus providing a *terminus post quem*;
d, which can be dated palaeographically

A table listing inscriptions is produced volume by volume.

ASSOCIATIONS

a, where the sculpture is in a primary position in an independently dated structure;
b, where the sculpture is associated with a structure which has an independently dated life span, although the sculpture itself is in a secondary position or in a portion of the structure of undetermined date;
c, where the sculpture is contained in a sealed and datable archaeological layer;
d, where the sculpture is associated with a site known from independent evidence to have had a limited life span

HISTORICAL CONTEXTS

where reliably recorded historical events sometimes seem to provide an appropriate context for changes and developments in style, for example, reigns of kings; foundations of bishoprics, monasteries, churches; travels of craftsmen or individuals

TYPOLOGY AND STYLE

These can give a relative series of sequences, some of which can be supported by historical contexts to give an additional probability. Thus the acceptance of Christianity within an area, or the Scandinavian settlements of the Danelaw provide a *terminus post quem* for the appearance of Christian motifs and Scandinavian motifs respectively. Changes in abstract ornament or more complex figural iconography may be related to better dated examples in other media, provided one can assume 'period' fashions which are likely to affect all media.

DISCUSSION

Inscriptions are of singularly little use in providing a chronological framework for this material. Most of those which are readable are so laconic or repetitive in their formulae that they do not lead to a precise dating. The names occurring can rarely be related to personages who are historically documented elsewhere.[8] The longest Anglo-Saxon inscriptions such as those concerned with the dedication of churches, for example, at Jarrow, Kirkdale or Deerhurst, are not associated with relief sculpture. Nevertheless more detailed work by palaeographers could be helpful in dating the letter forms of inscribed texts which, though shorter, might be compared with letter forms in manuscripts.[9] There are few closely dated pre-Conquest churches and in these sculpture is rarely in a primary context (Taylor 1978). By far the greater number of pieces of sculpture have to be dated by a combination of historical context and stylistic analysis, which can provide a working framework and significant groupings but not an exact chronology.

The dates proposed are therefore only an indication of this present framework. They have been put in notional quarter or half centuries, but on occasion the use of a numerical system could provide more accurate dating. The modifying regional factors which influence the chronological framework are indicated in the introduction to each volume.

Until more localized studies are undertaken it is impossible to understand national developments. It is clear that circumstances of production (who the patrons

8. The names recorded on the lost Glastonbury 'pyramids' have been used to provide a date for those monuments and so have those on the difficult runic inscriptions at Bewcastle. However, it is clear from the Hackness stone that crosses could be raised to persons who had been dead for some time. Similarly, the simple formula – 'pray for X' – is unhelpful if X is unknown. For a discussion of this problem see Clapham 1930, 61–2 and notes.
9. See the work by Elizabeth Okasha (1964–8 and 1971) and by John Higgitt (1979).

were, who and how many the sculptors were, as well as the functions of the sculptures) are all modifying factors in understanding developments. In order to isolate and identify the work of an individual carver, or small groups working closely together possibly in a small workshop, a close analysis should ideally be made not only of the repertoire of motifs and their stylistic treatment, but also such technological traits as the unit measures for the layout of ornament or tool types employed. However, differential weathering of the material often makes this difficult to determine.

It is clear that there is not a steady development but that inception and changes in ornament occur at different times from area to area and that there are sudden bursts of activity and equally unaccountable periods of stagnation. Even the beginning of distinctive new forms, such as the adoption of the free-standing cross or the hogback grave-stone, do not occur at the same time throughout England. There are, moreover, repeated returns to old motifs of Classical or Germanic ornament. These problems are discussed in the introductions to the individual volumes. However it will always be necessary to look outside the area of the volume to wider parallels, whilst being conscious that for this period other media can also only provide a very imperfect account of the original picture.

CHAPTER VI
EPIGRAPHY

A table listing inscriptions is produced volume by volume.

Runic letters and inscriptions have been transliterated, following the system devised by Dickins (1932), into lower-case Roman letters (Fig. 28). These are distinguished from non-runic letters and inscriptions, which have been transcribed, whatever the letter forms of the original, using upper-case Roman letters.

The line-division of the original has been retained throughout wherever possible, the symbol Ƶ being used to indicate a line-break which does not occur in the original. Where necessary for clarity, the inscription is given a second time with word-division and punctuation, but without line-division. Latin letter forms are classified as capital (Roman or other), uncial, Insular half-uncial (also known as majuscule), or minuscule.

In addition, the following conventions are used:

| | | interruption of an inscription by a zone of ornament |

(ab) expansion of abbreviations where expansion is certain

(ab) expansion of abbreviations uncertain; letters printed those preferred by text editor

[ab] letters damaged, reading certain

[*ab*] letters damaged, reading uncertain; letters printed those preferred by text editor

[. .] two letters damaged and illegible

[——] uncertain number of letters damaged and illegible

—— *lacuna* of unknown length at start or end of line

⟨ab⟩ letters omitted in error and inserted by stone carver

⟨*ab*⟩ letters omitted in error and supplied by text editor

{ab} superfluous letters added by stone carver

a̅b̅ mark of contraction

ab' mark of suspension

a/b conjoined runic letters ('bind-runes')

* reading certain, but character unidentifiable

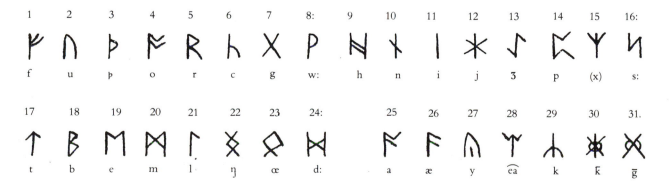

FIGURE 28
Runes: System of Transliteration

LIST OF REFERENCES AND GENERAL WORKS
FOR CONSULTATION

Titles of periodicals are abbreviated according to the American Standard ASA Z. 39–5. 1963, as used by the Council for British Archaeology.

Åberg, N. F., 1943	*The Occident and the Orient in the Art of the Seventh Century*, I, *The British Isles* (Kungl. Vitterhets Historie och Antikvitets Akademiens Handlingar, LVI, i)
Adcock, G., 1974	'A study of the types of interlace on Northumbrian sculpture' (Unpublished M.Phil. thesis, University of Durham)
Allen, J. R., 1894	'Notes on the ornamentation of the Early Christian monuments of Wiltshire', *Wiltshire Archaeol. Natur. Hist. Mag.*, XXVII, 50–65
Allen, J. R., 1895	'The Early Christian monuments of Cheshire and Lancashire', *Chester Archaeol. Soc.*, n. ser., V, 133–74
Allen, J. R., 1903	*The Early Christian Monuments of Scotland* (Edinburgh)
Allen, J. R., and Browne, G. F., 1885	'The crosses at Ilkley. Part III (conclusion)', *J. Brit. Archaeol. Ass.*, XLI, 333–58
Bain, G., 1951	*The Methods of Construction of Celtic Art* (Glasgow)
Belli, I. B., 1959	*Corpus della scultura altomedievale*, I, *La Diocesi di Lucca* (Spoleto)
Brøndsted, J. (trans. A. F. Major), 1924	*Early English Ornament....* (London and Copenhagen)
Brown, G.B. (ed. E. H. L. Sexton), 1937	*Anglo-Saxon Sculpture. The Arts in Early England*, VI, ii (London)
Bruce-Mitford, R. L. S., 1960	'Decoration and miniatures', part IV in T. D. Kendrick *et al.*, *Evangeliorum Quattuor Codex Lindisfarnensis*, II (Olten and Lausanne)
Clapham, A. W., 1930	*English Romanesque Architecture before the Conquest* (Oxford)
Collingwood, W. G., 1907	'Anglian and Anglo-Danish sculpture in the North Riding of Yorkshire', *Yorkshire Archaeol. J.*, XIX, 267–413
Collingwood, W. G., 1909	'Anglian and Anglo-Danish sculpture at York', ibid., XX, 149–213
Collingwood, W. G., 1911	'Anglian and Anglo-Danish sculpture in the East Riding, with addenda relating to the North Riding', ibid., XXI, 254–302
Collingwood, W. G., 1915	'Anglian and Anglo-Danish sculpture in the West Riding, with addenda to the North and East Ridings and York, and a general review of the Early Christian monuments of Yorkshire', ibid., XXIII, 129–299
Cottrill, F., 1935	'Some pre-Conquest stone carvings in Wessex', *Antiq. J.*, with introduction by A. W. Clapham, XV, 144–51
Davies, D. S., 1926	'Pre-Conquest carved stones in Lincolnshire', with introduction by A. W. Clapham, *Archaeol. J.*, LXXXIII, 1–20
Dickins, B., 1932	'A system of transliteration for Old English runic inscriptions', *Leeds Studies in English*, I, 15–19
Fossard, D., Vieillard-Troiekouroff, M., and Chatel, E., 1978	*Monuments sculptés en France (ive–xe siècles)*, I (Paris)

1

Fox, C., 1922 'Anglo-Saxon monumental sculpture in the Cambridge district', *Proc. Cambridge Antiq. Soc.,* XXIII, 15–45

Green, A. R., and
 Green, P. M., 1951 *Saxon Architecture and Sculpture in Hampshire* (Winchester)

Haseloff, G., 1958 'Fragments of a hanging-bowl from Bekesbourne, Kent, and some ornamental problems', *Medieval Archaeol.,* II, 72–103

Henry, F., 1933 *La Sculpture irlandaise pendant les douze premiers siècles de l'ère chrétienne* (Paris)

Higgitt, J., 1979 'The dedication inscription at Jarrow and its context', *Antiq. J.,* LIX, 343–74

Hodges, H., 1964 *Artefacts* (London)

Kendrick, T. D., 1938 *Anglo-Saxon Art to A.D. 900* (London)

Kendrick, T. D., 1949 *Late Saxon and Viking Art* (London)

Kermode, P. M. C., 1907 *Manx Crosses, or the Inscribed and Sculptured Monuments of the Isle of Man* (London)

Kitzinger, E., 1936 'Anglo-Saxon vinescroll ornament', *Antiquity,* X, 61–71

Lang, J. T., 1967 'Hogbacks in north-eastern England' (Unpublished M.A. thesis, University of Durham)

Lexow, E., 1921–2 'Hovedlinierne i entrelacornamentikkens historie', *Bergens Museums Aarbok*

Marquardt, H., 1961 *Bibliographie der Runeninschriften nach Fundorten,* I, *Die Runeninschriften der britischen Inseln* (Göttingen)

Nash-Williams, V. E., 1950 *The Early Christian Monuments of Wales* (Cardiff)

Okasha, E., 1964–8 'The non-runic scripts of Anglo-Saxon inscriptions', *Trans. Cambridge Bibliographical Soc.,* IV, 321–38

Okasha, E., 1971 *Hand-list of Anglo-Saxon Non-runic Inscriptions* (Cambridge)

Page, R. I., 1973 *An Introduction to English Runes* (London)

Routh, R. E., 1937 'A corpus of the pre-Conquest carved stones of Derbyshire', with introduction by W. G. Clark-Maxwell, *Archaeol. J.,* XCIV, 1–42

Stuart, J., 1856 *Sculptured Stones of Scotland,* I (2 ed., Edinburgh)

Stuart, J., 1867 *Sculptured Stones of Scotland,* II (2 ed., Edinburgh)

Taylor H. M., 1978 *Anglo-Saxon Architecture,* III (Cambridge)

Taylor, H. M., and
 Taylor, J., 1965 *Anglo-Saxon Architecture,* I, II (Cambridge)

Taylor, J., and
 Taylor, H. M., 1966 'Architectural sculpture in pre-Norman England' *J. Brit. Archaeol. Ass.,* ser. 3, XXIX, 3–51

Thiel, E. J., 1970 'Neue Studien zur ornamentalen Buchmalerei des früheren Mittelalters', *Archiv für Gesch. des Buchwesens,* XI, 1057–1126

Toynbee, J. M. C., and
 Ward Perkins, J. B., 1950 'Peopled scrolls: a Hellenistic motif in imperial art', *Papers of British School at Rome,* XVIII, 1–43